MEDIEVAL MODERN MONSTERS
PLUS BONUS COLORING PAGES

The subject matter of this book is inspired by medieval illustrations from manuscripts. These images were placed on the edge of the manuscript but I have made them the focus of the image. In fact they are the total image.

This book starts out with demons devouring people, lost souls in hell and walking demons. The medieval world was obsessed with demons and today is no different just look at the political climate. There are many demons there !!!

The next set of images are inspired by Danse Macabre, otherwise known as the Dance of Death. These images are populated with dancing, and musical instrument playing skeleton. I updated the image to include several ones with the skeleton playing a guitar.

Furthermore I couldn't do a medieval book without some creatures. There are two images of an unknown creature 12 legs, a tail and two heads that inhabited the lakes and oceans. You can't forget about the mythical unicorn. My image the unicorn seems to have "come undone." Like he is scared to be seen. I had to include a fairy but not just any fairy but a smokin' hot fairy !!! Ok, I don't know if there were fairies in medieval times but I had to include this. The last two images have nothing really to do with the medieval world but they seem to fit in with the other images. They are of an old ad for an elixir that promised to make children and adults as fat as pigs !!! Can you imagine !!! Try Tasteless Grove's Chill Tonic

GUARANTEED TO MAKE YOU AND YOUR CHILDREN AS FAT AS PIGS !!! THAT SOUNDS LIKE MEDIEVAL THINKING TO ME !!!

LASTLY I DECIDED TO END THIS BOOK WITH BLACK AND WHITE VERSIONS OF ALL THE IMAGES SO YOU CAN COLOR YOUR OWN MEDIEVAL MODERN MONSTERS ANY WAY YOU CHOSE TO !!! TO MAKE THEM YOUR OWN !!!

ENJOY LOOKING AT AND COLORING YOUR OWN MEDIEVAL MODERN MONSTERS !!!!!

THANKS , PATRICK B. HUMPHREYS , JULY 2016

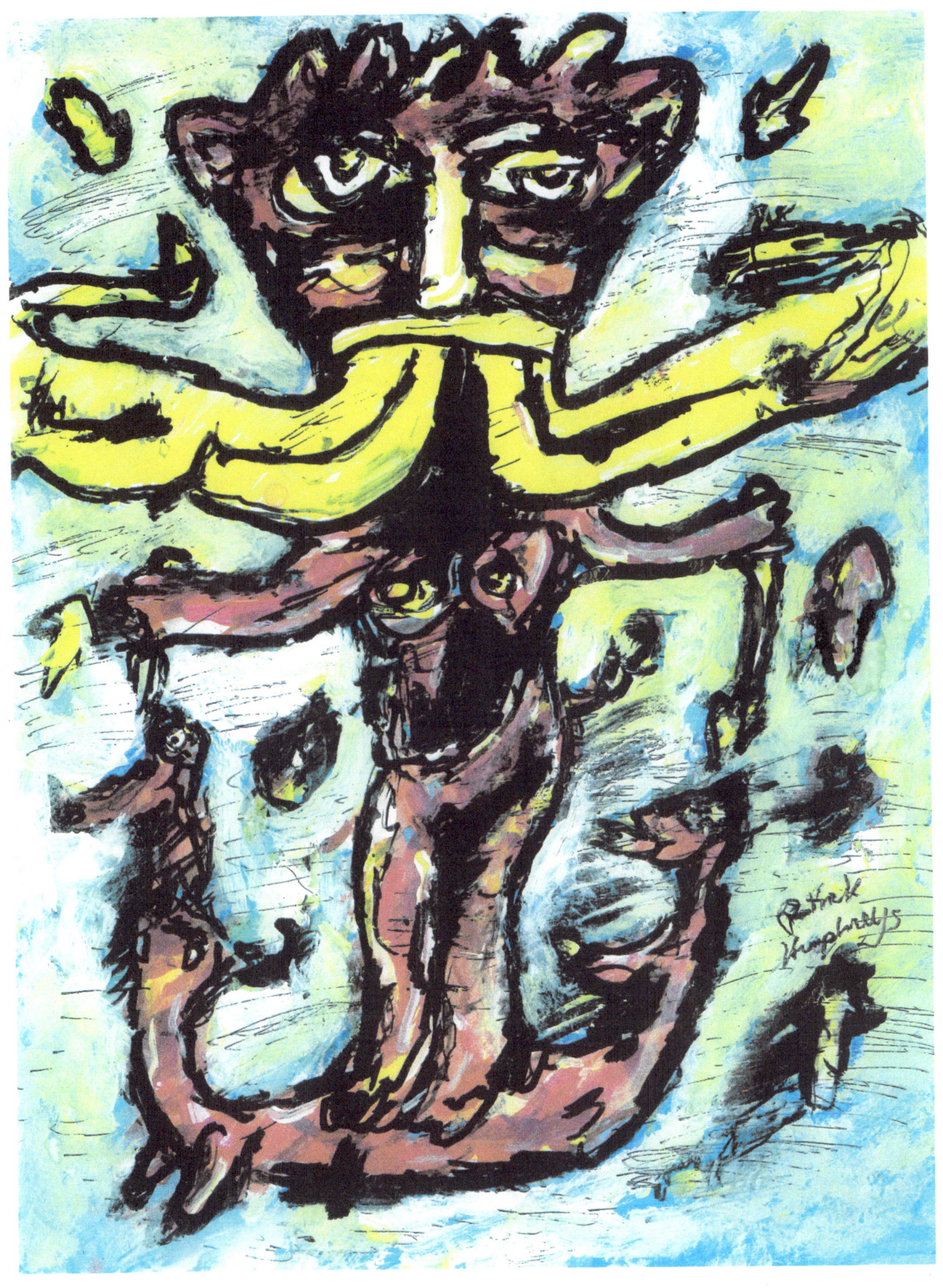

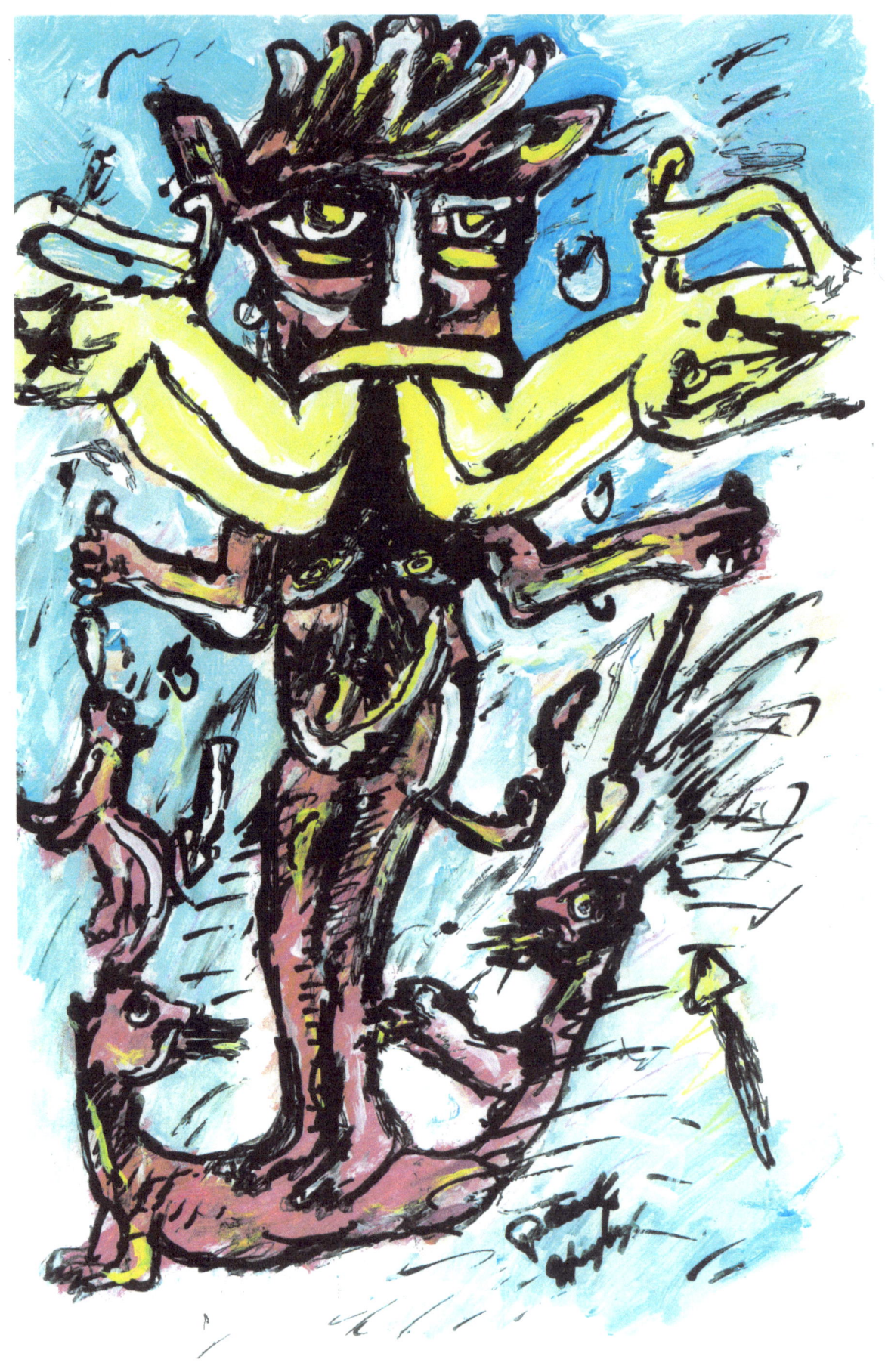

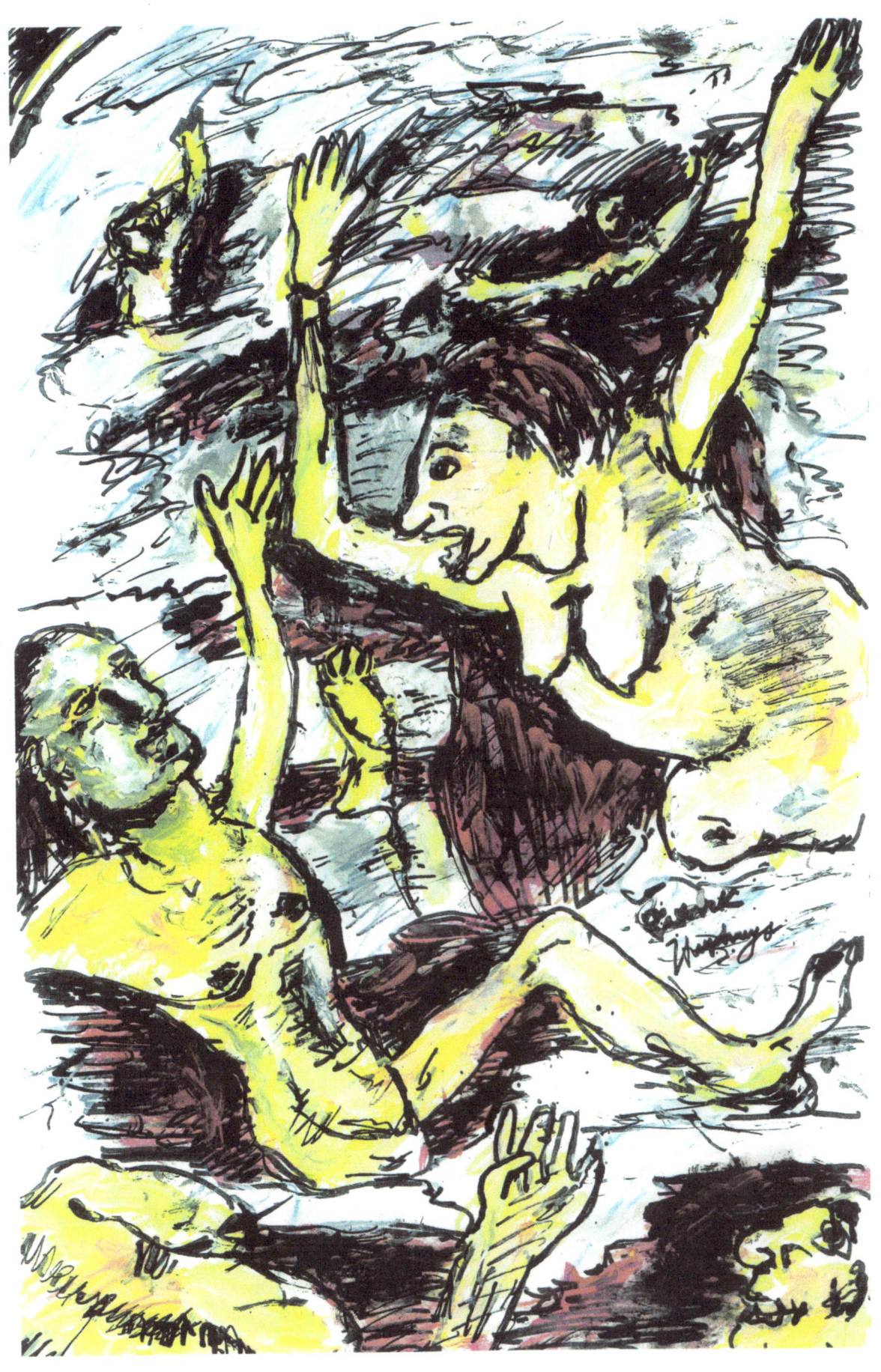

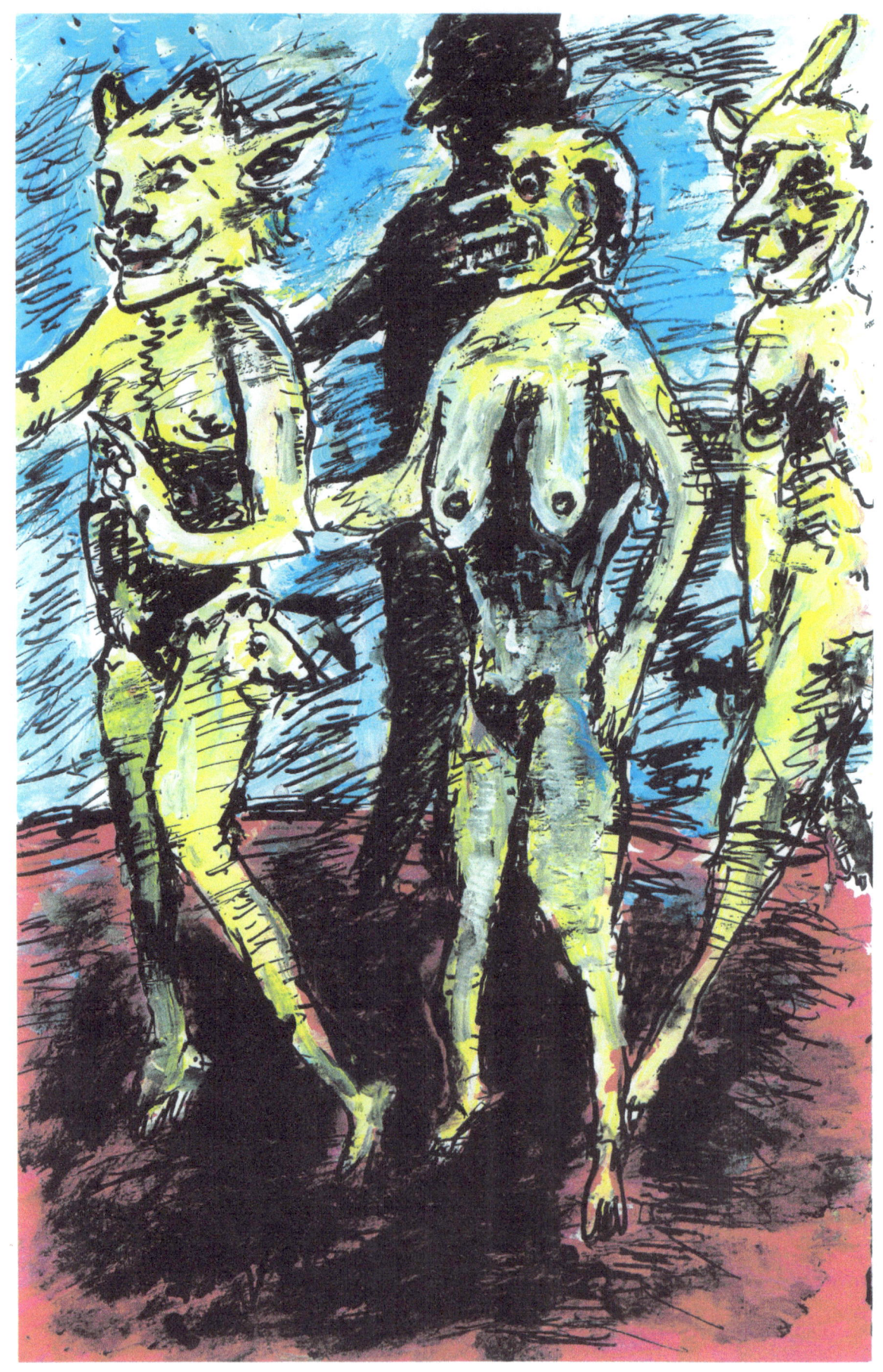

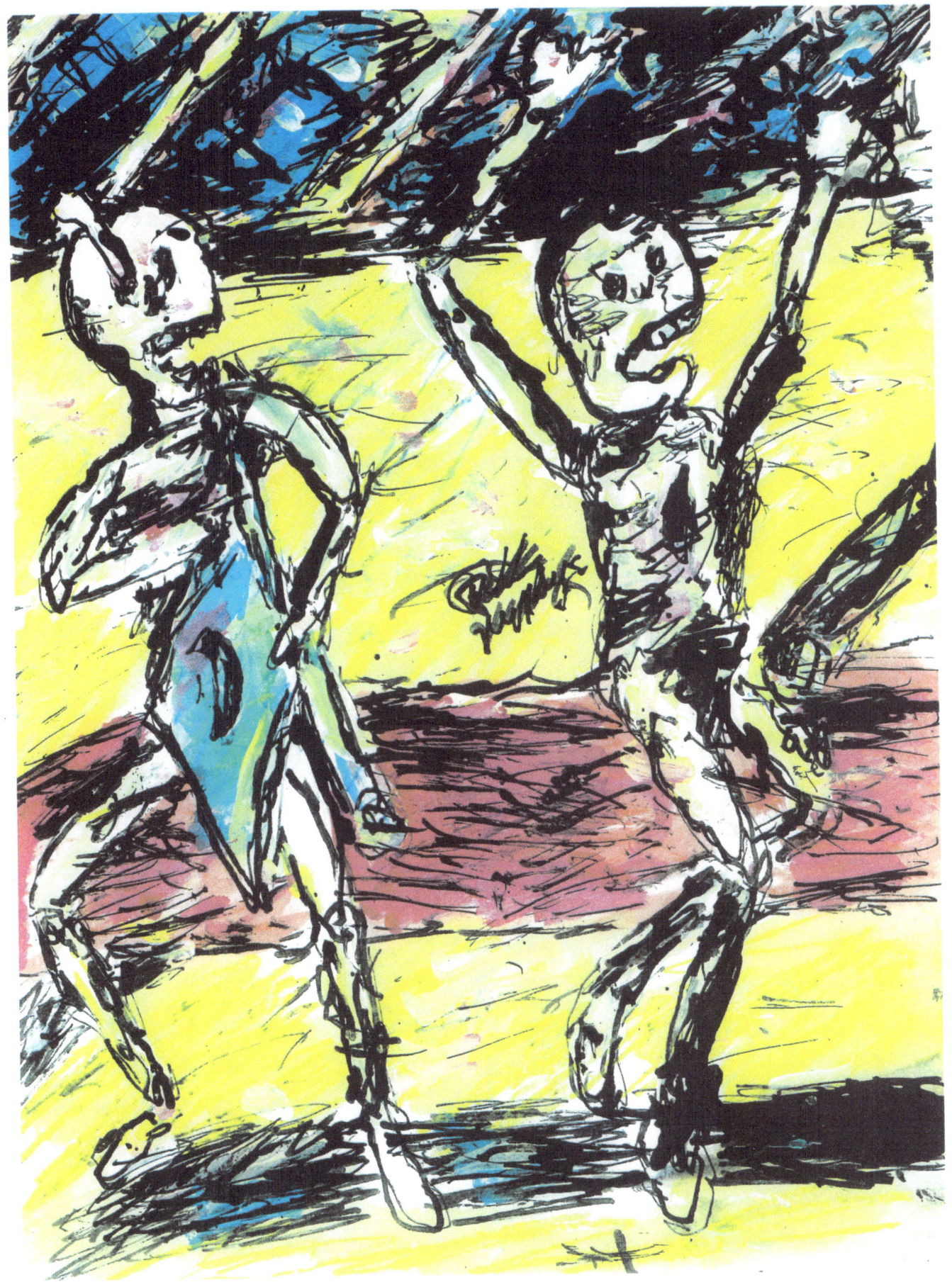

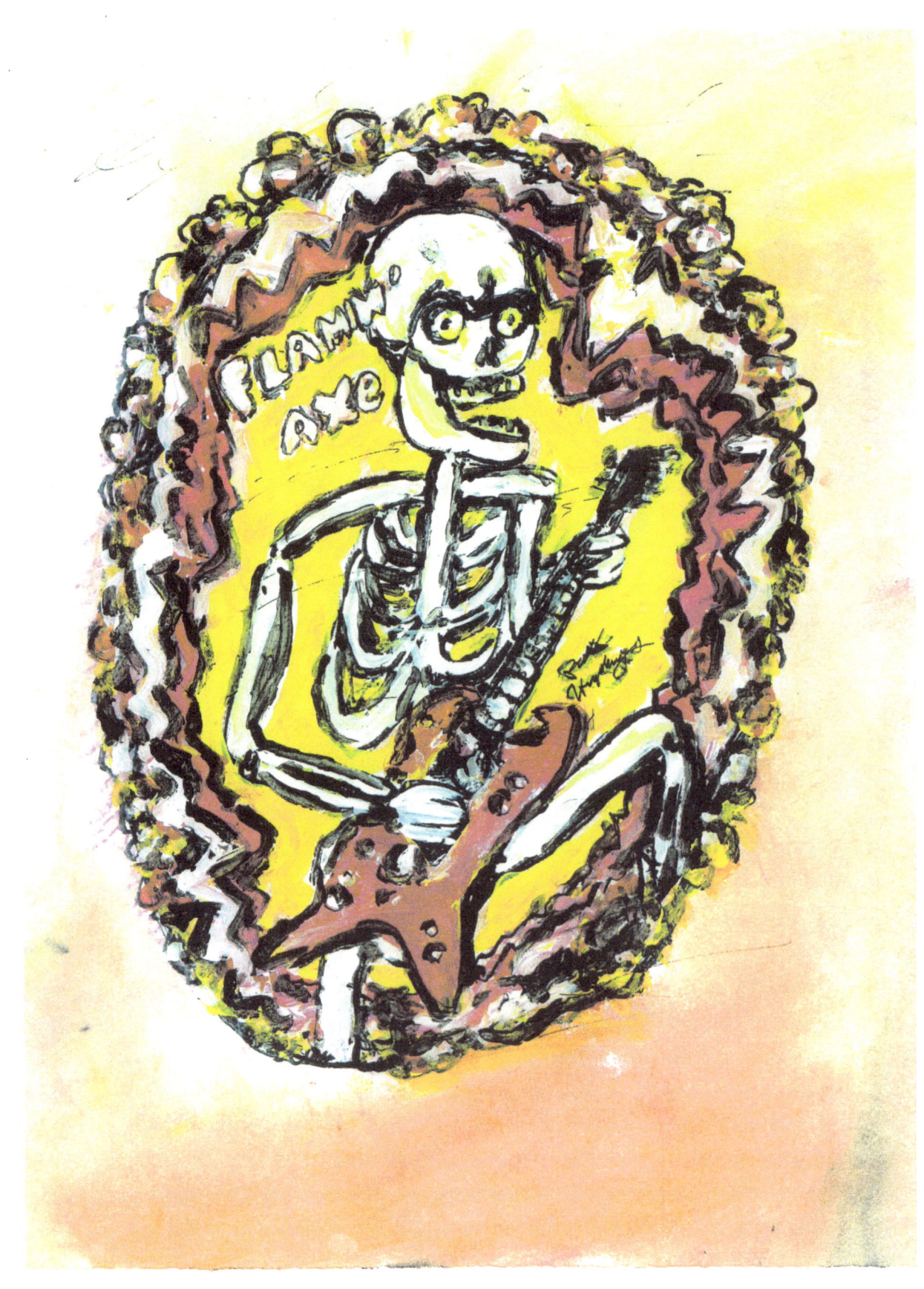

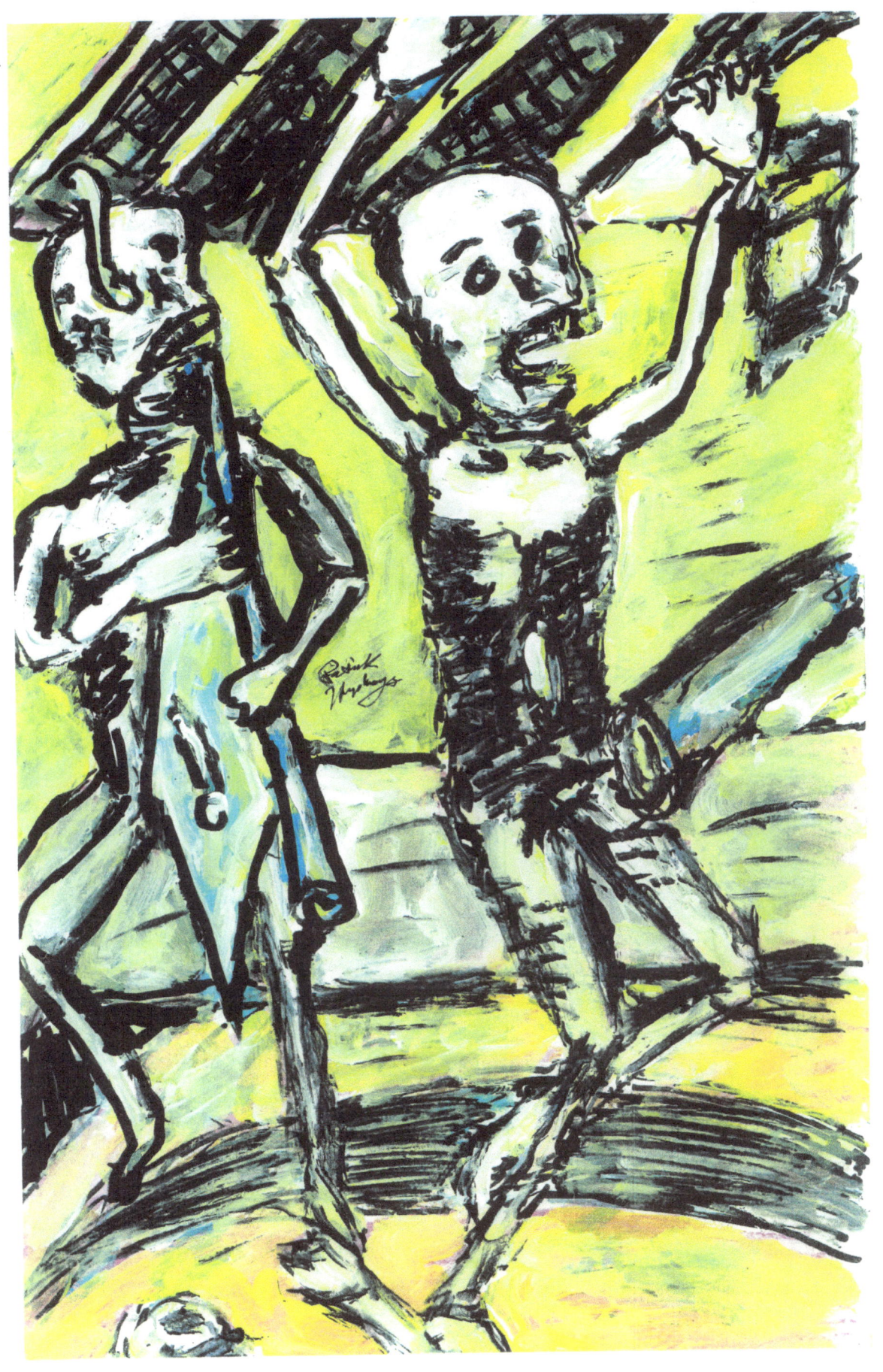

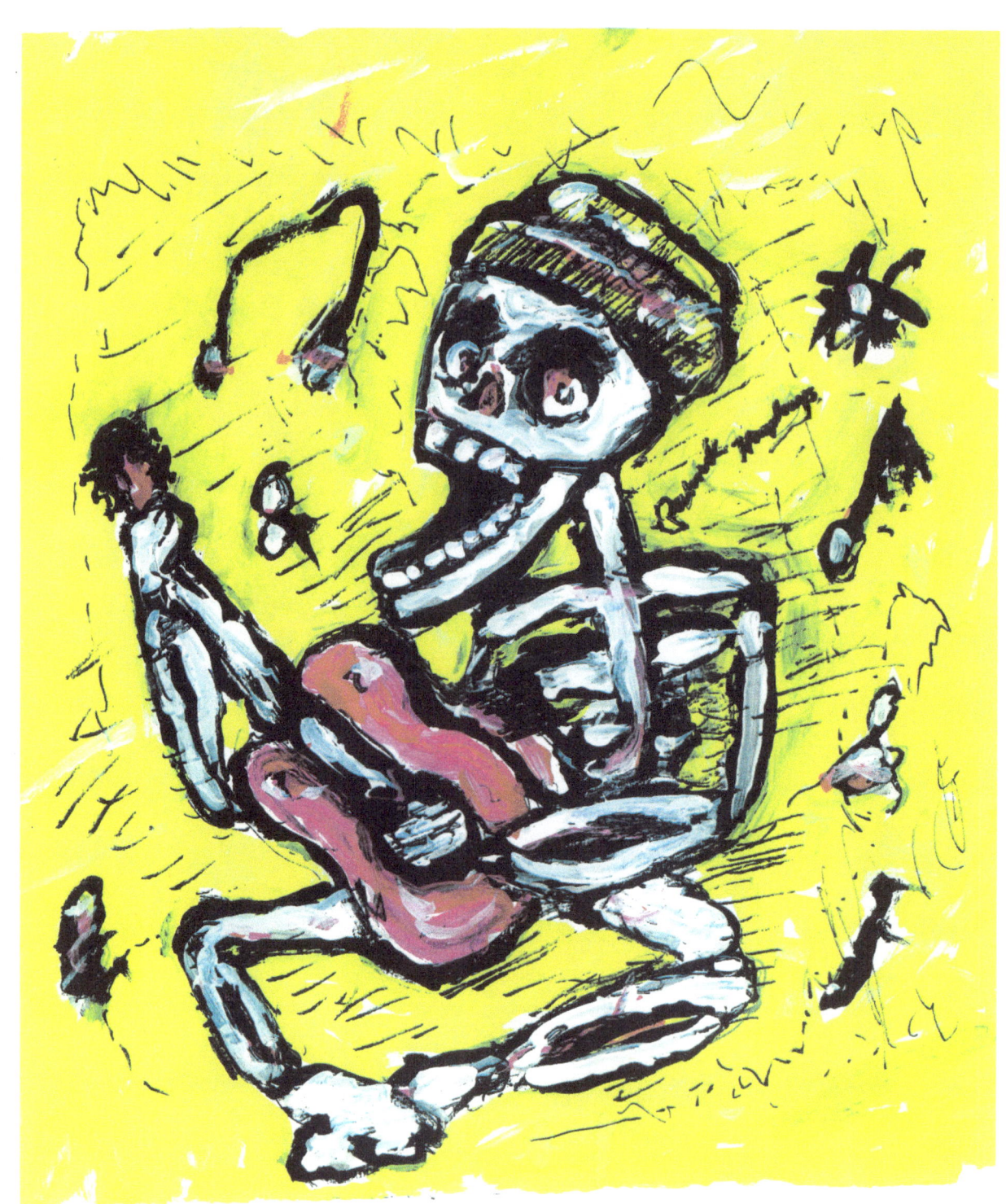

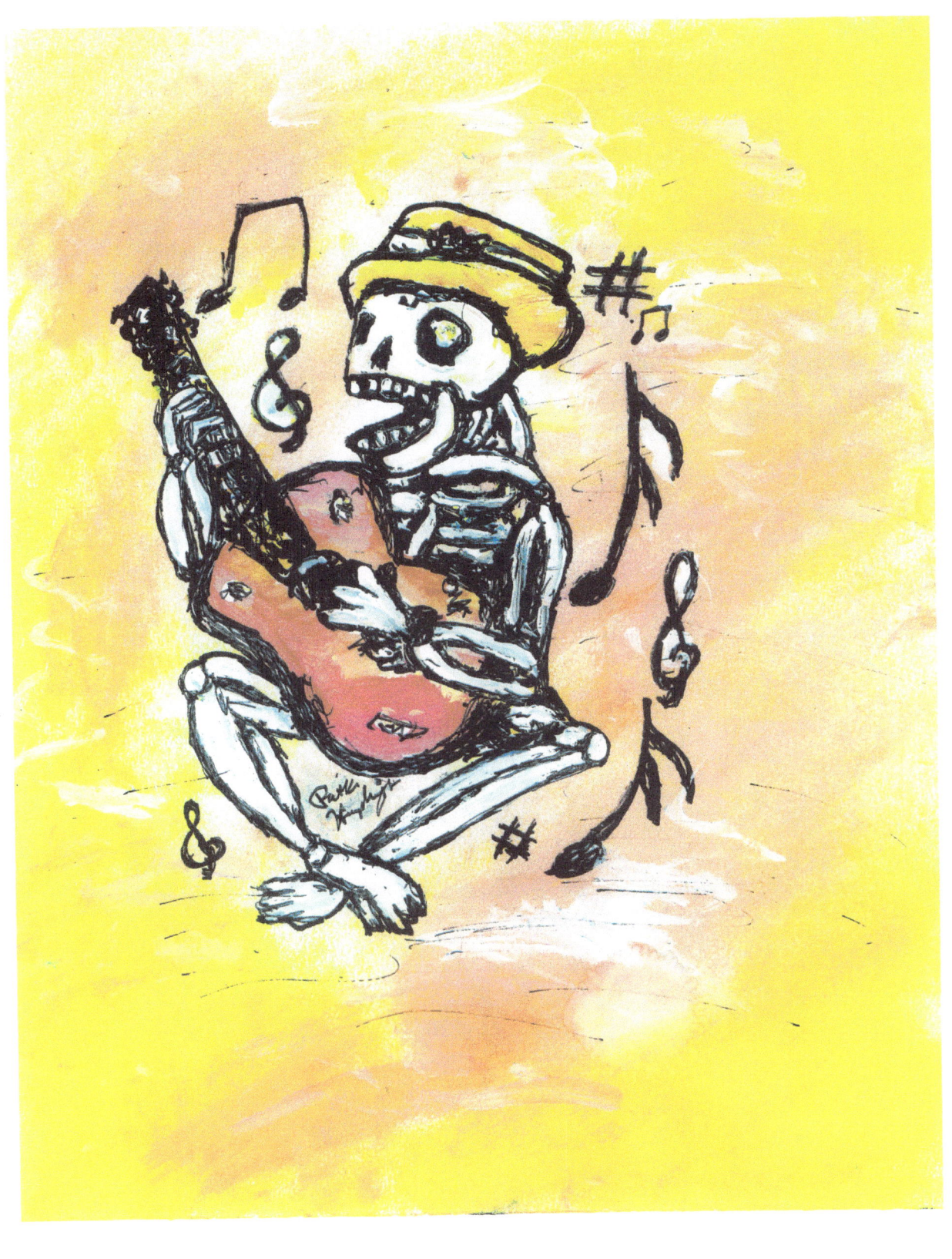

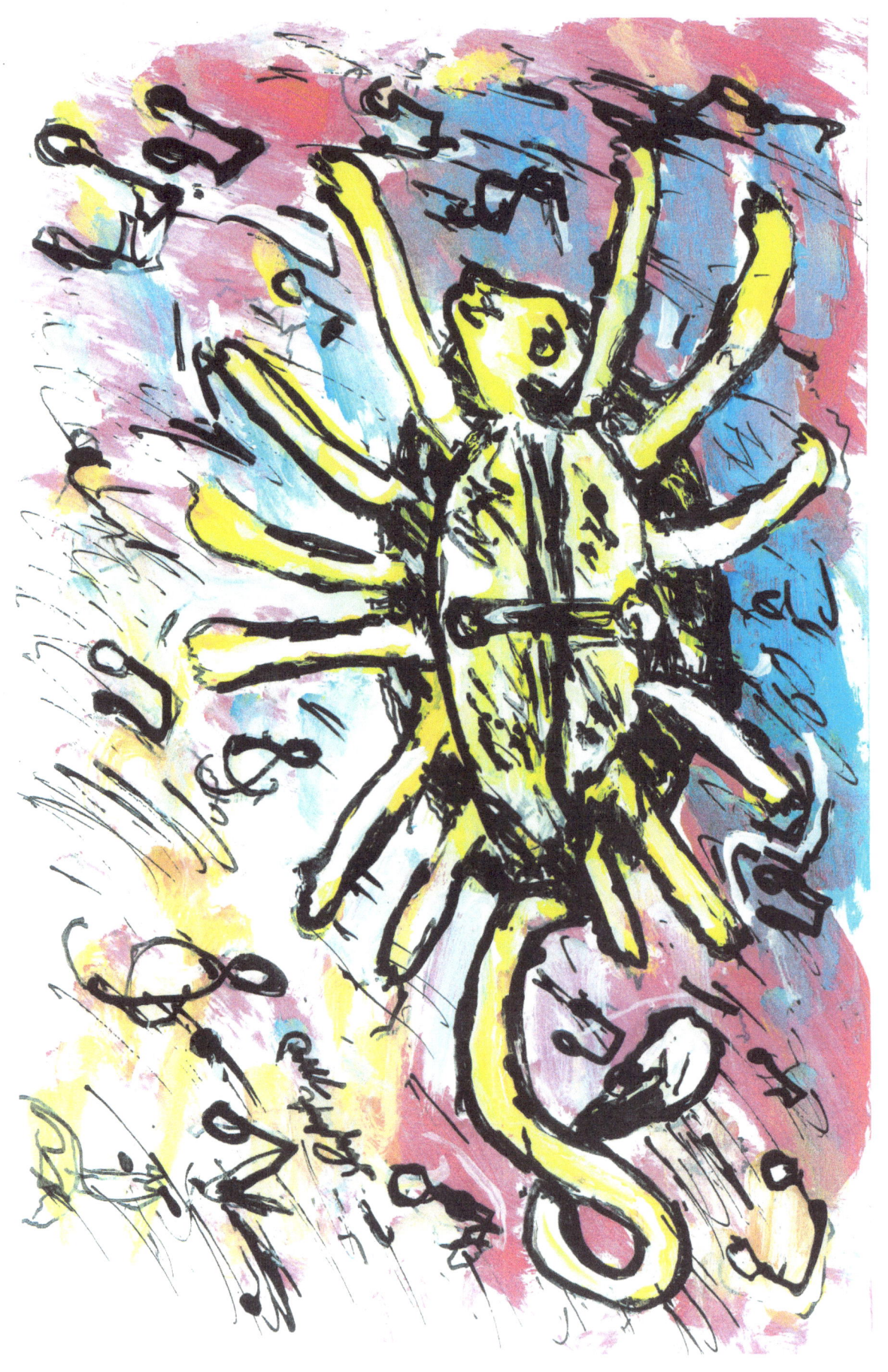

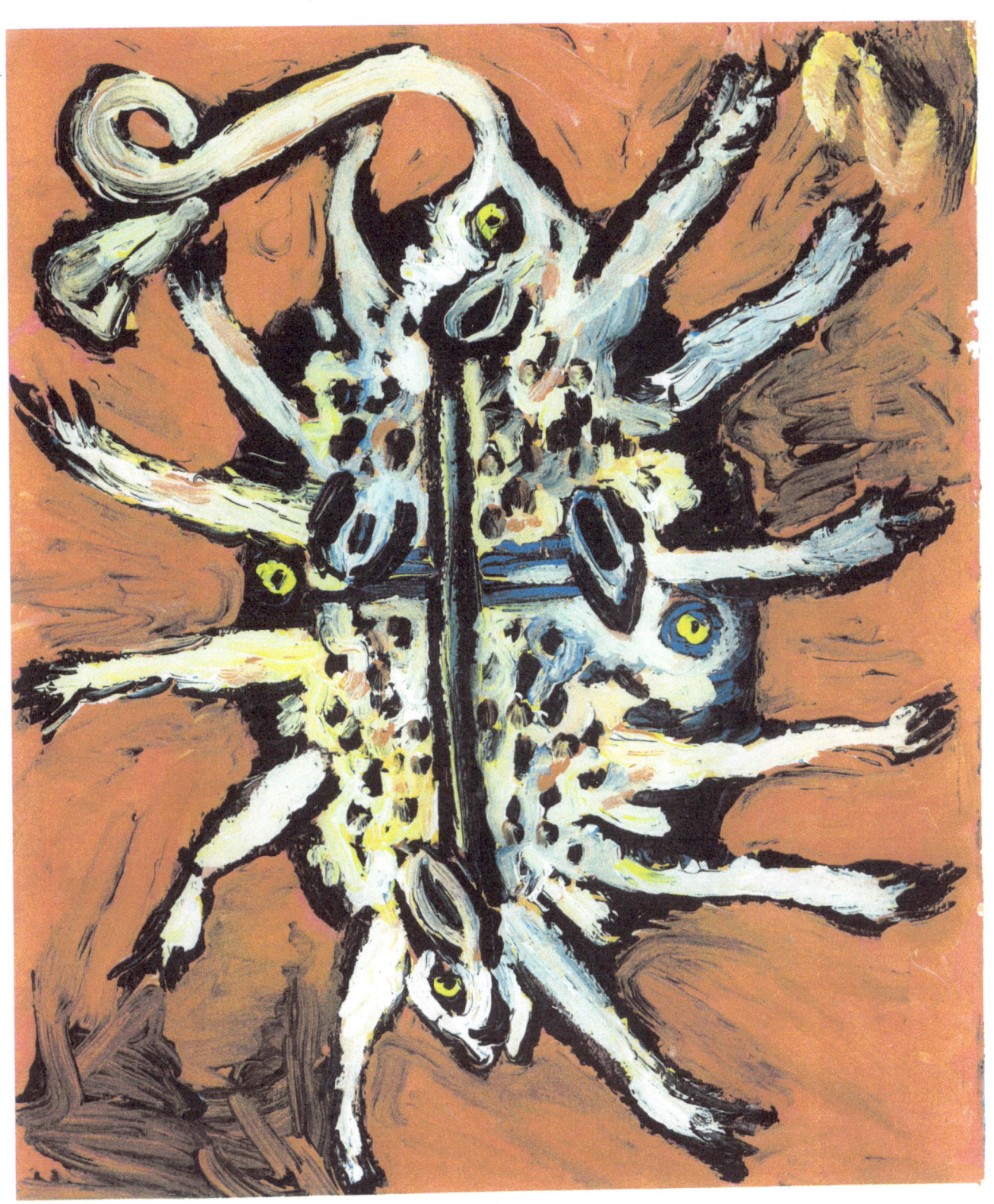

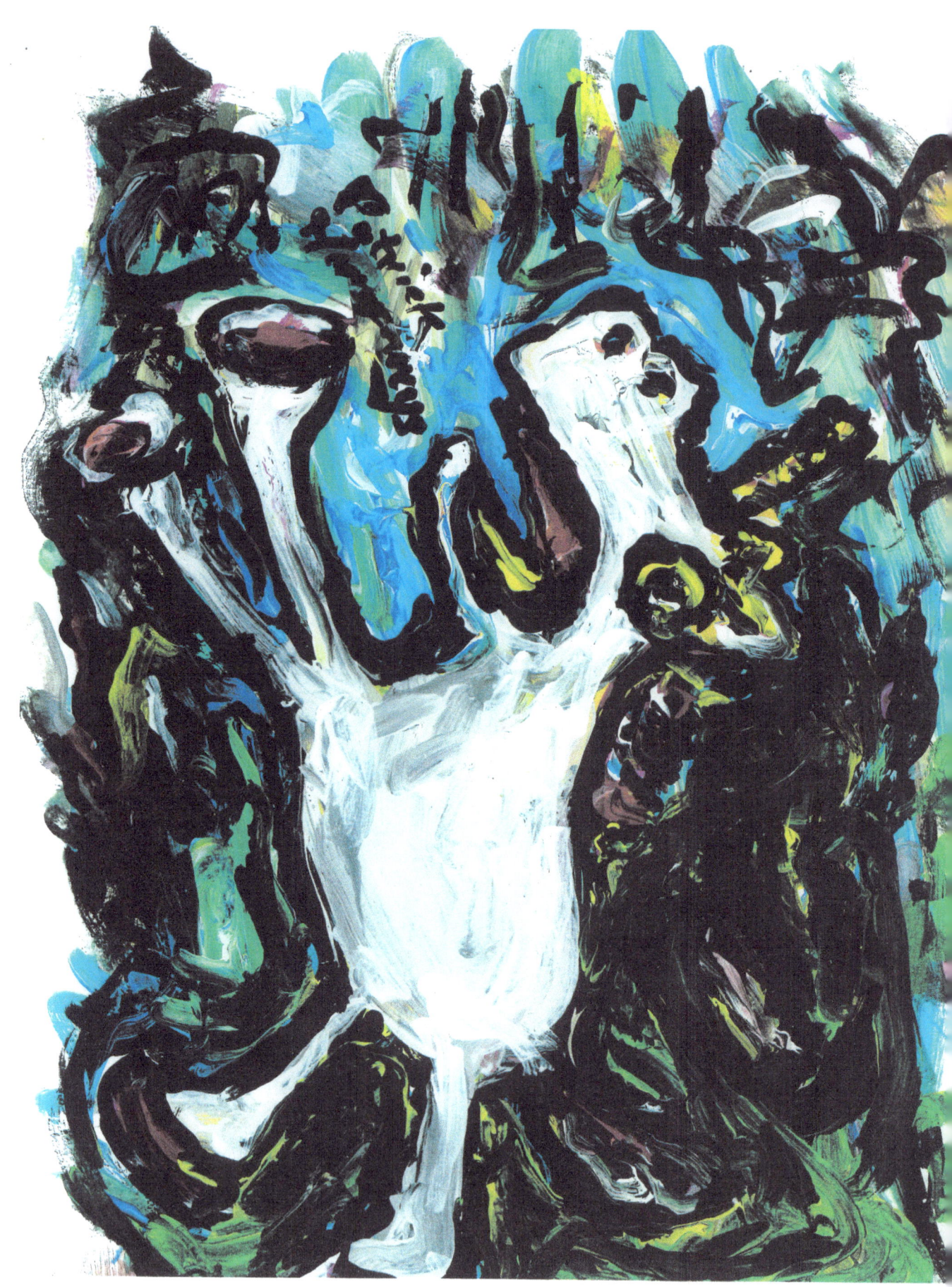

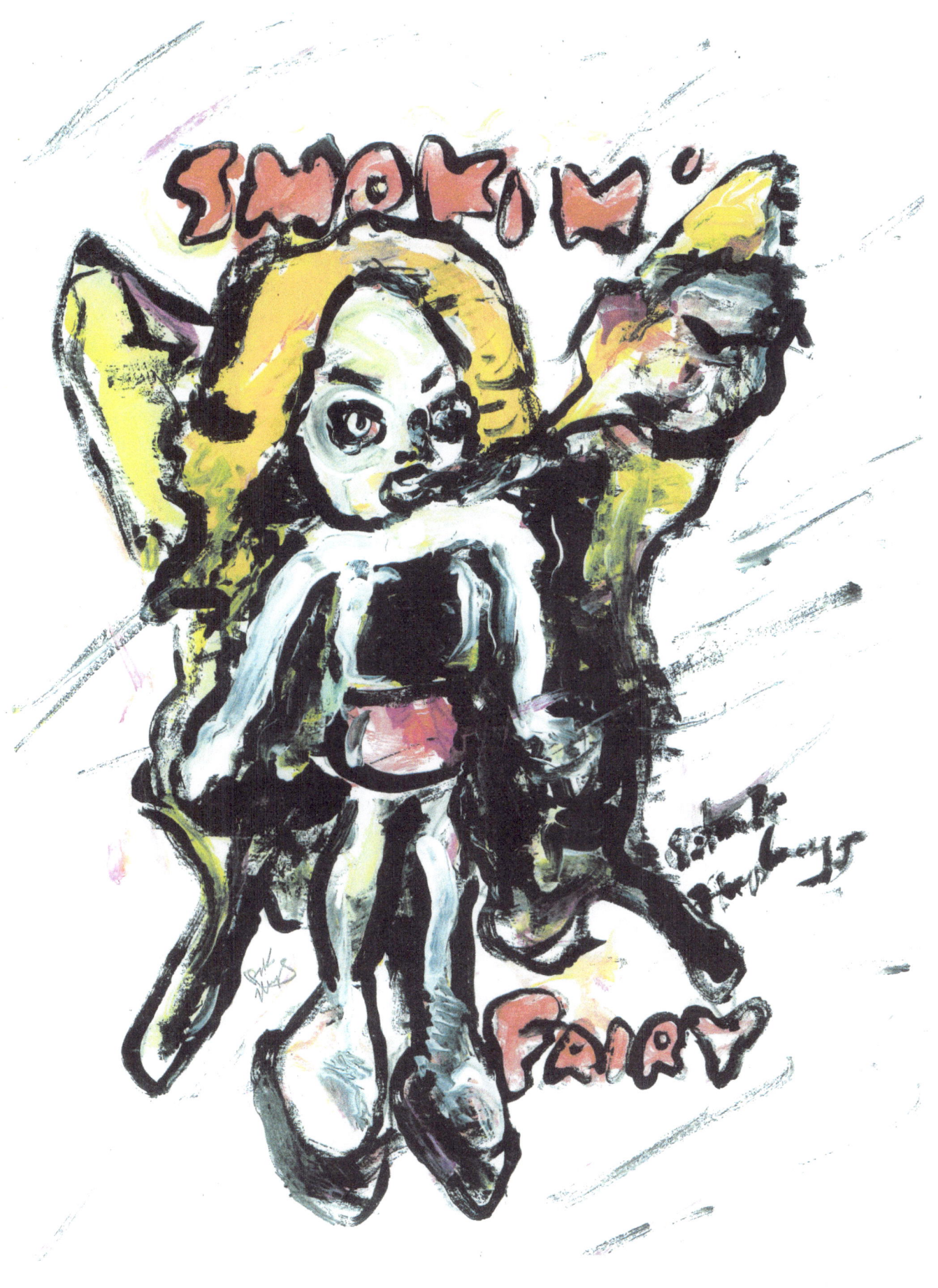

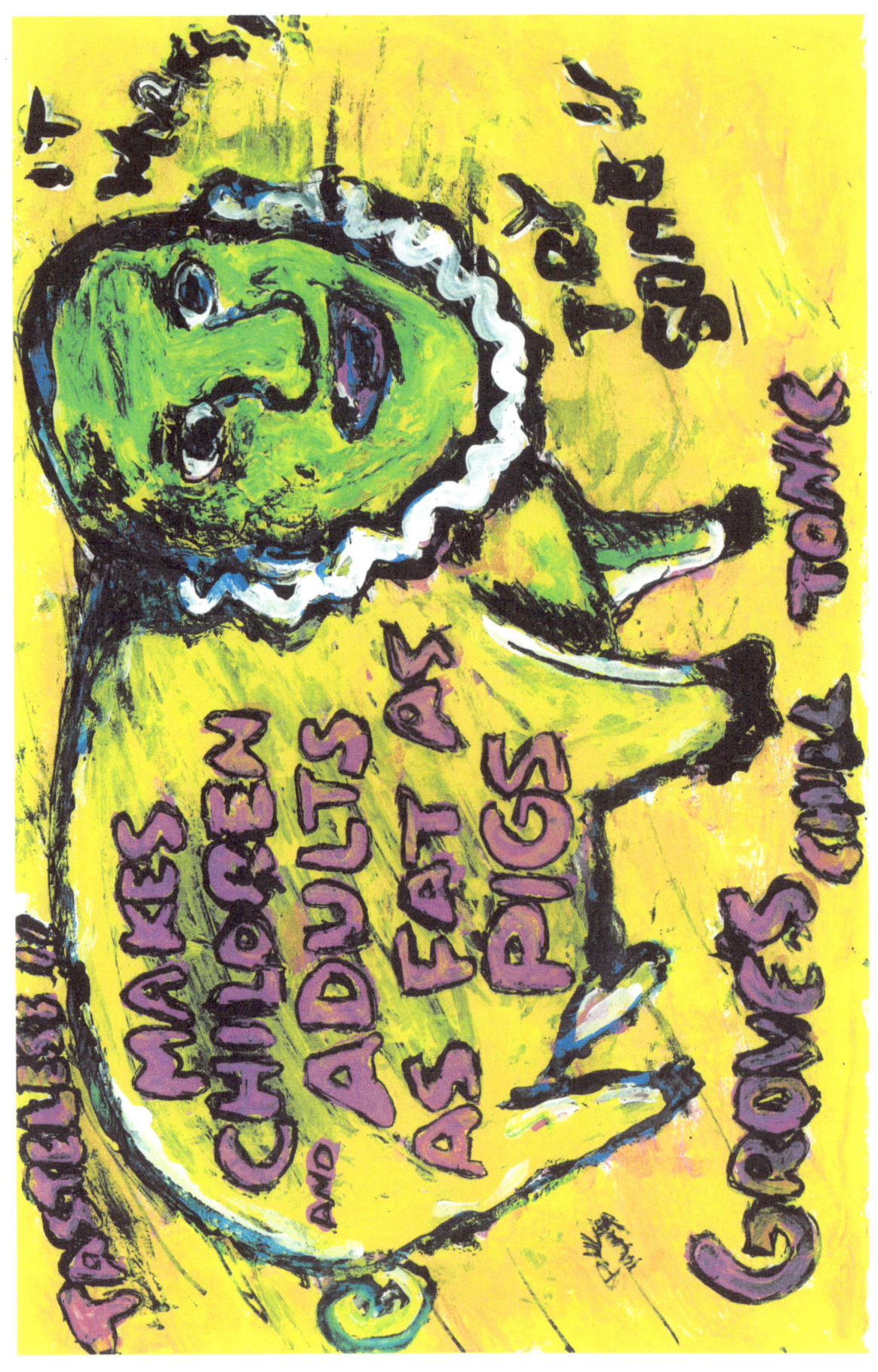

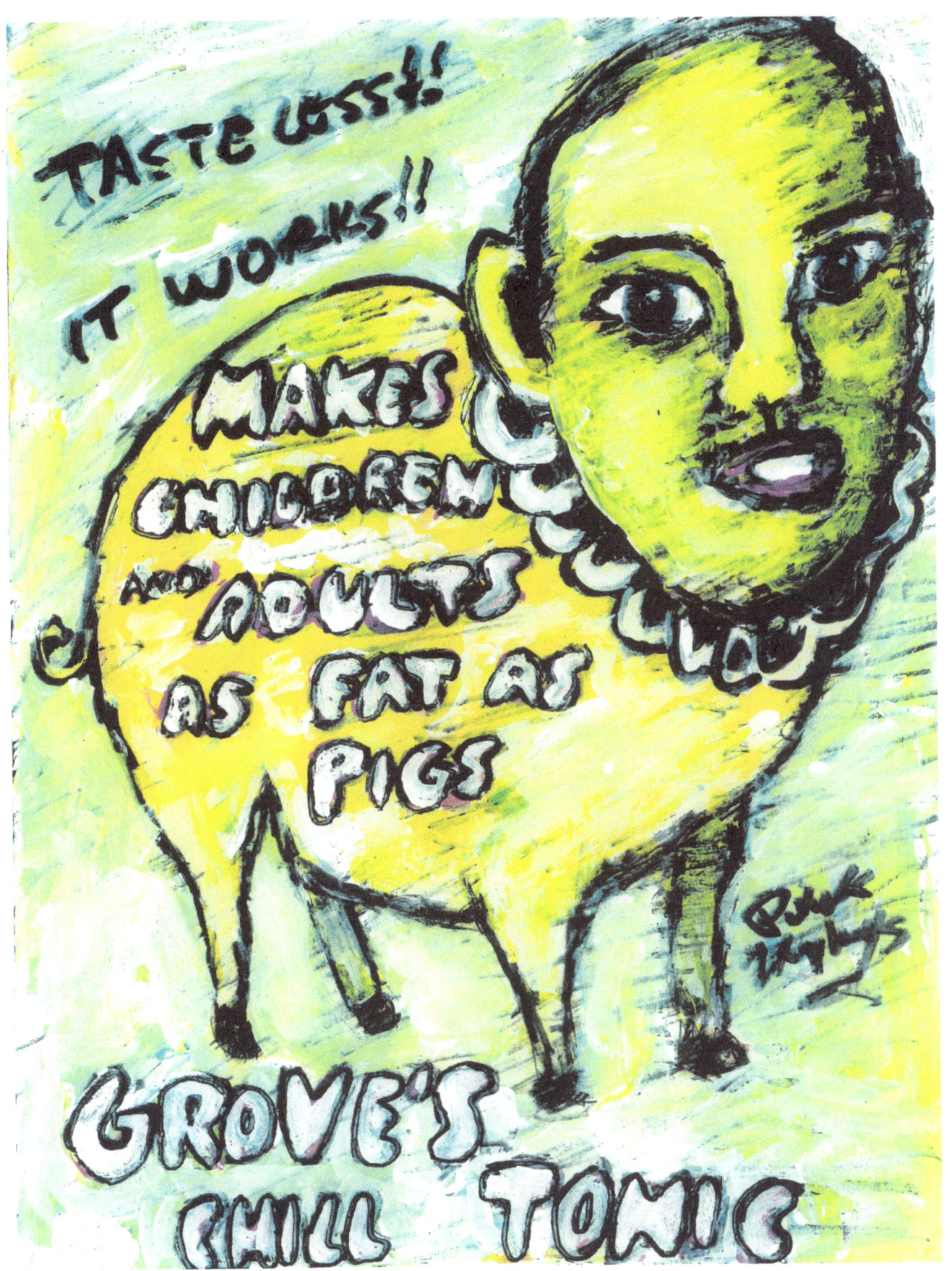

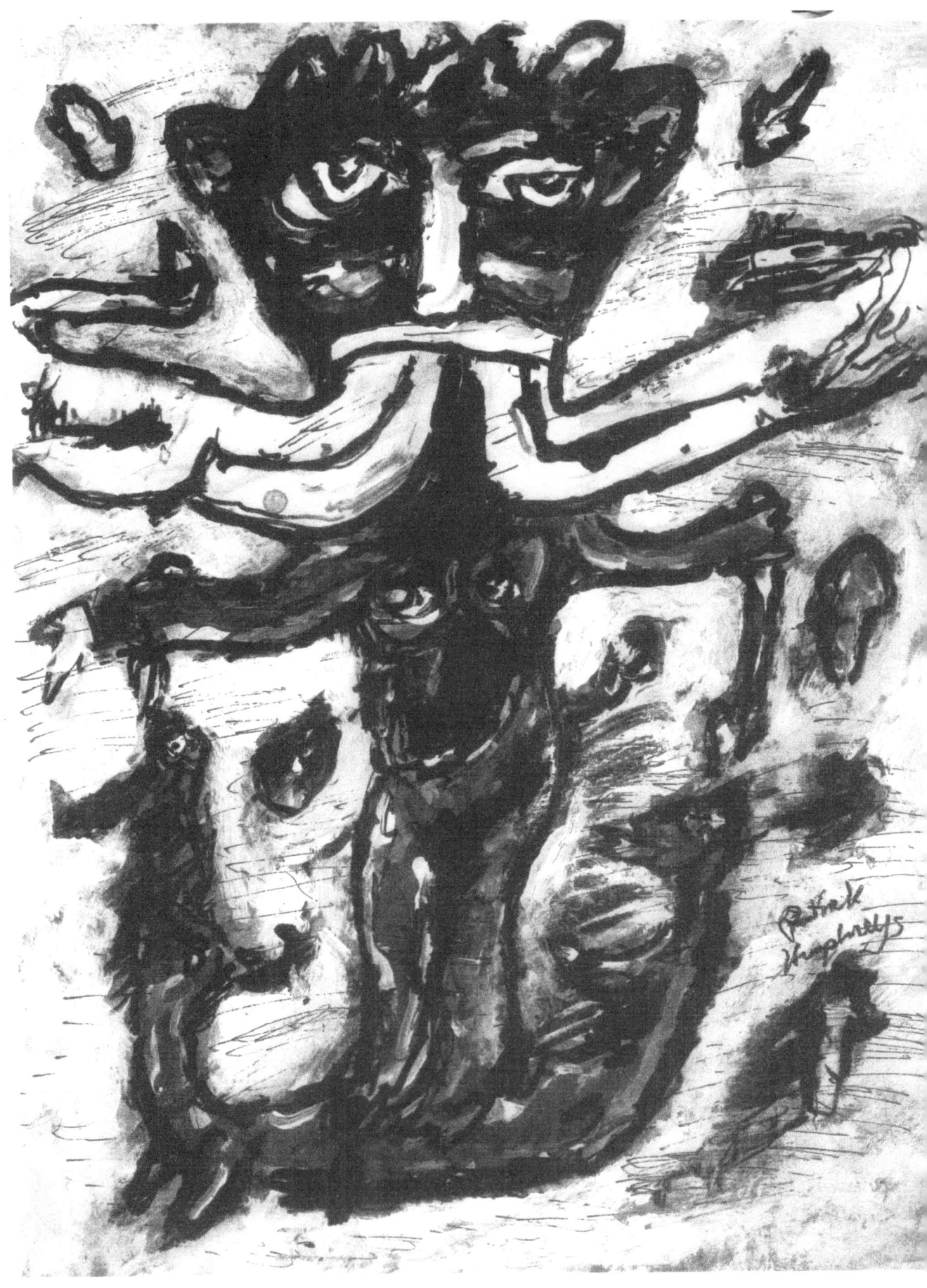

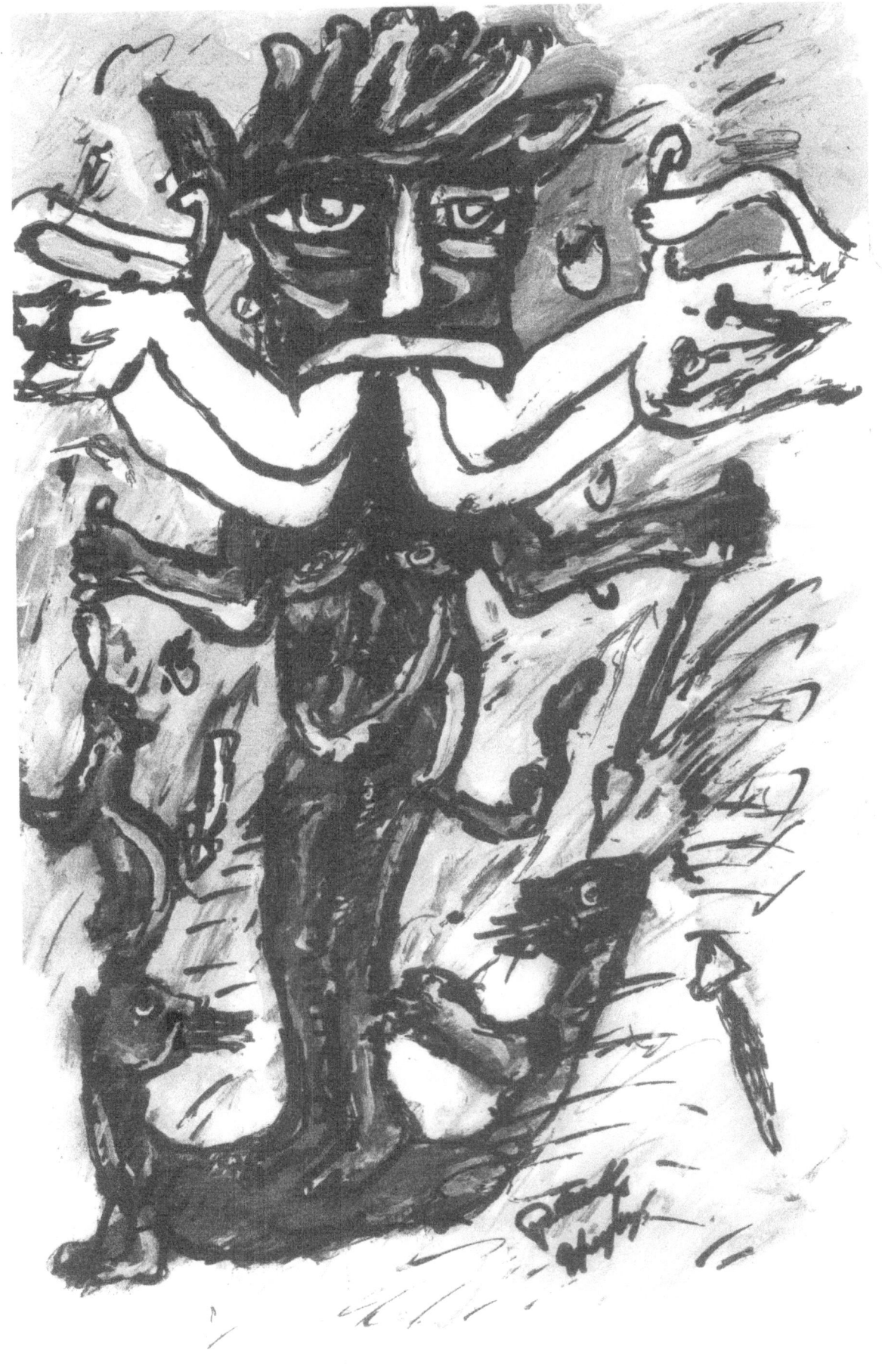

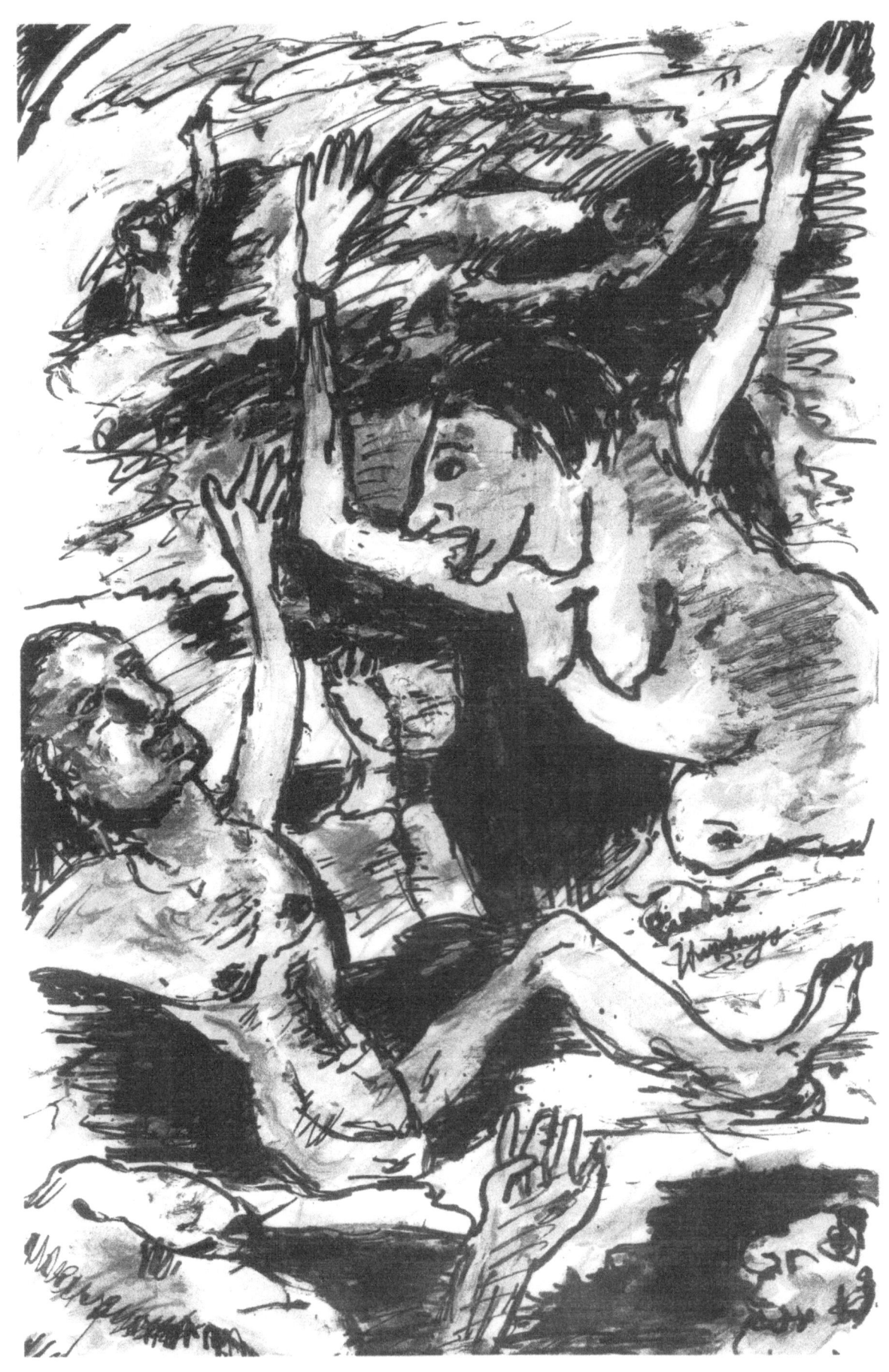

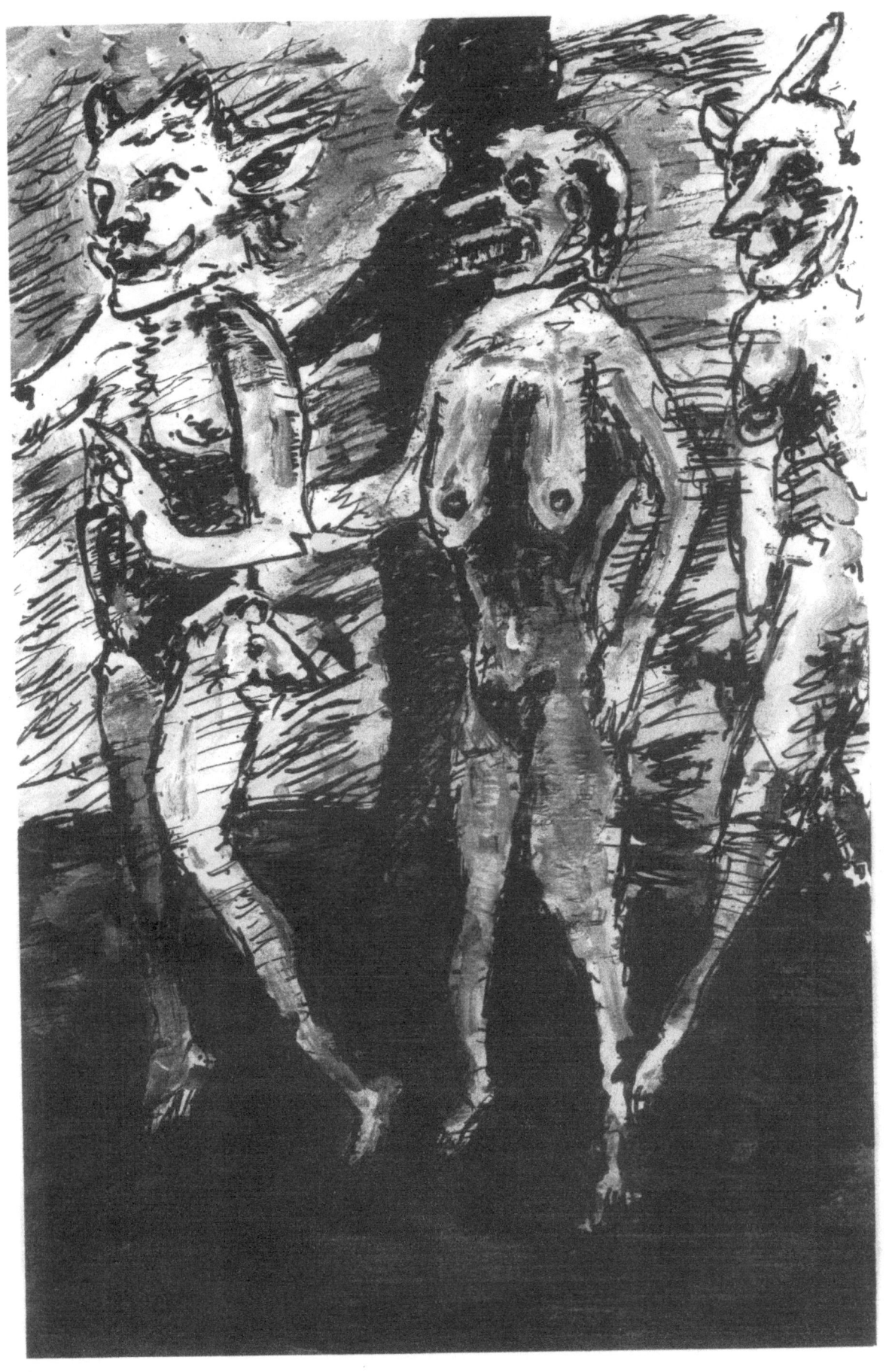

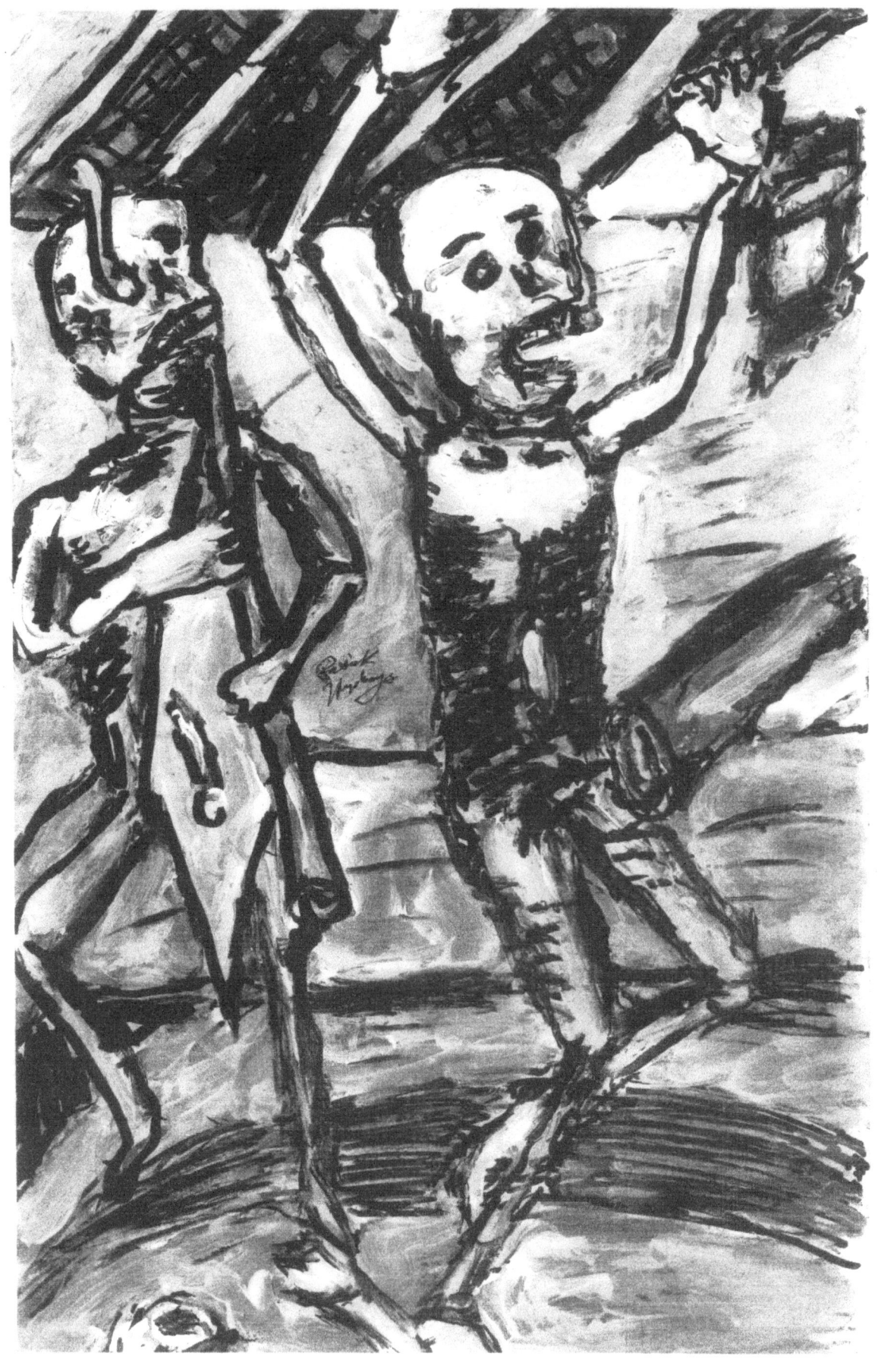

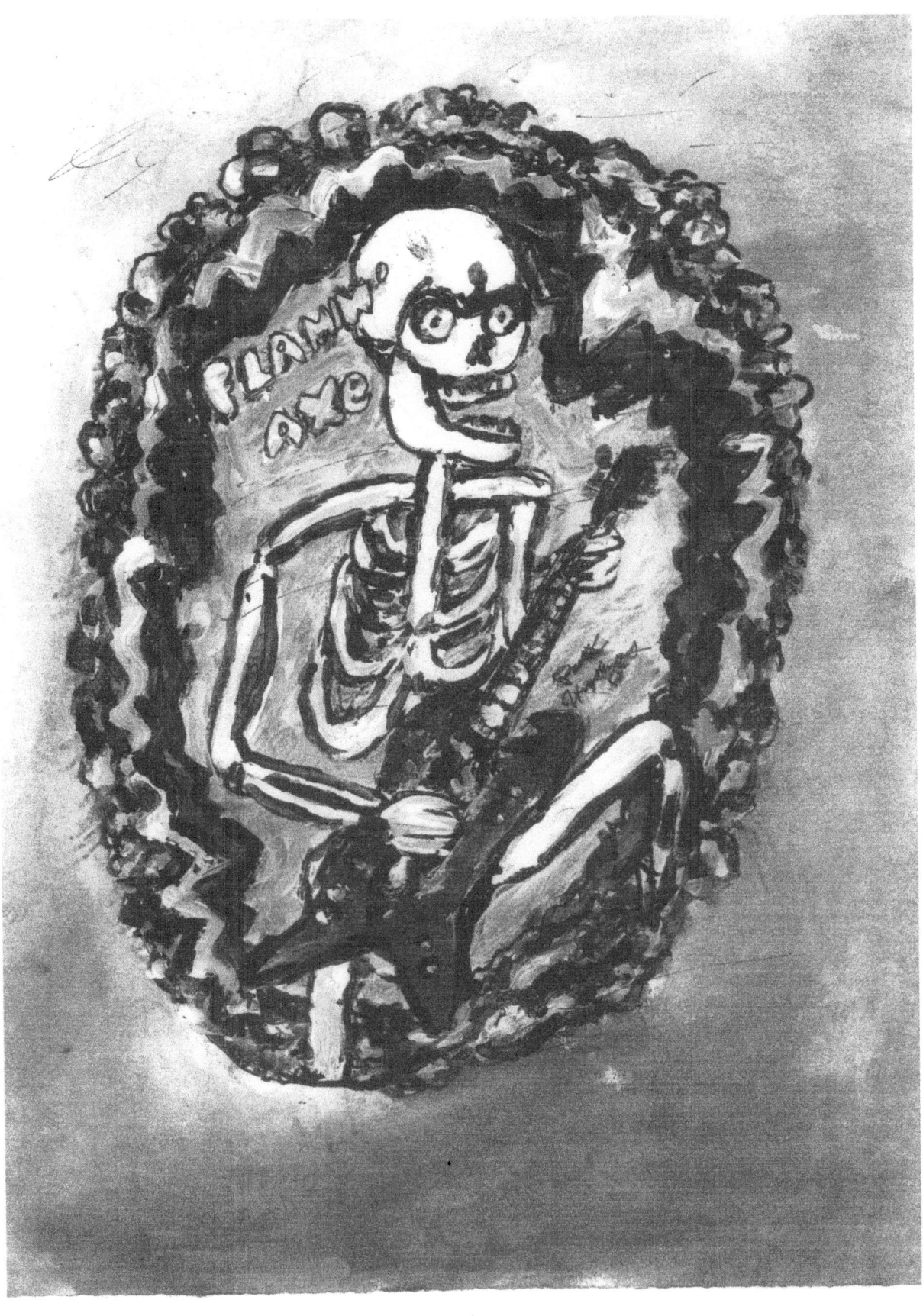

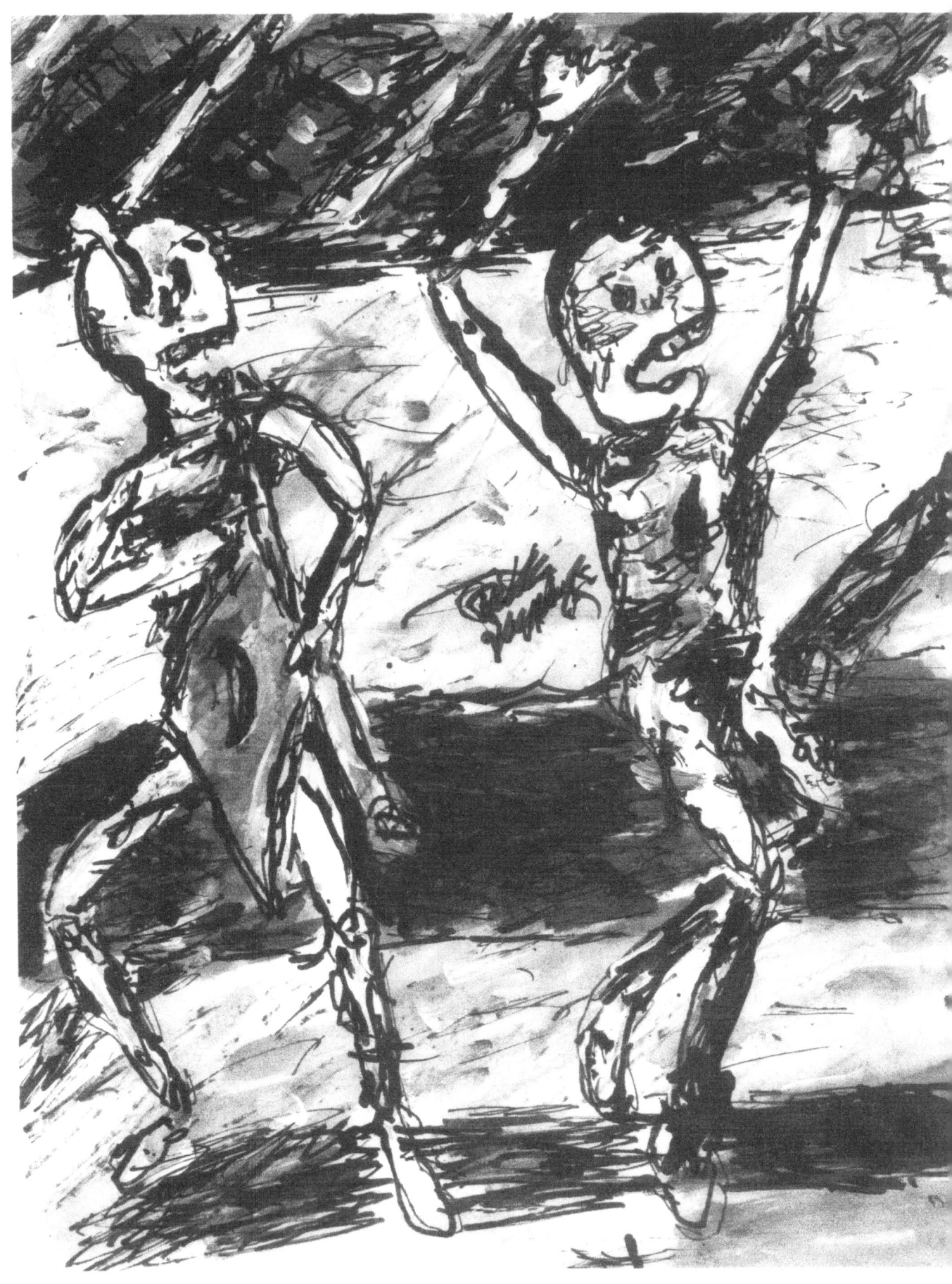

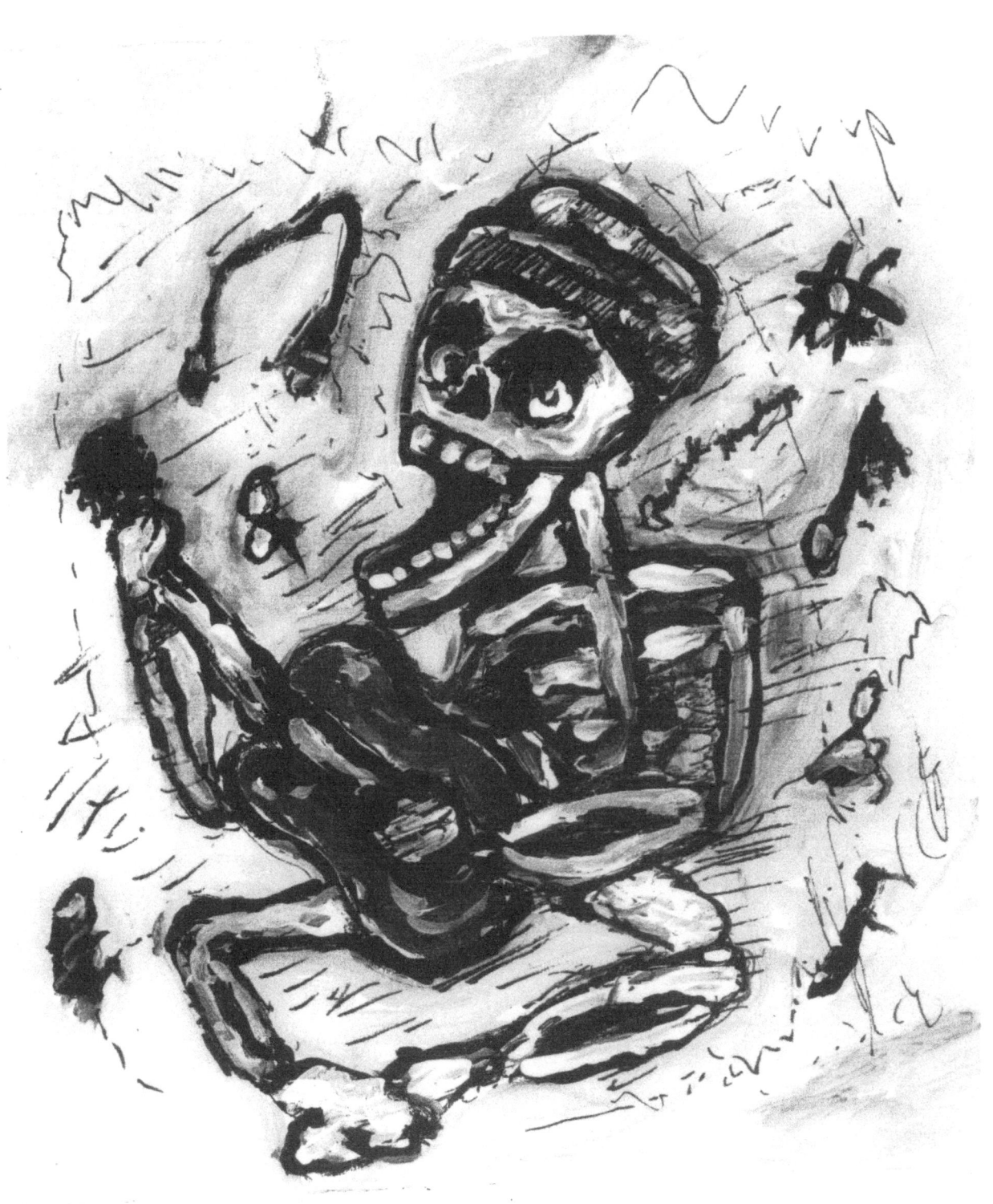

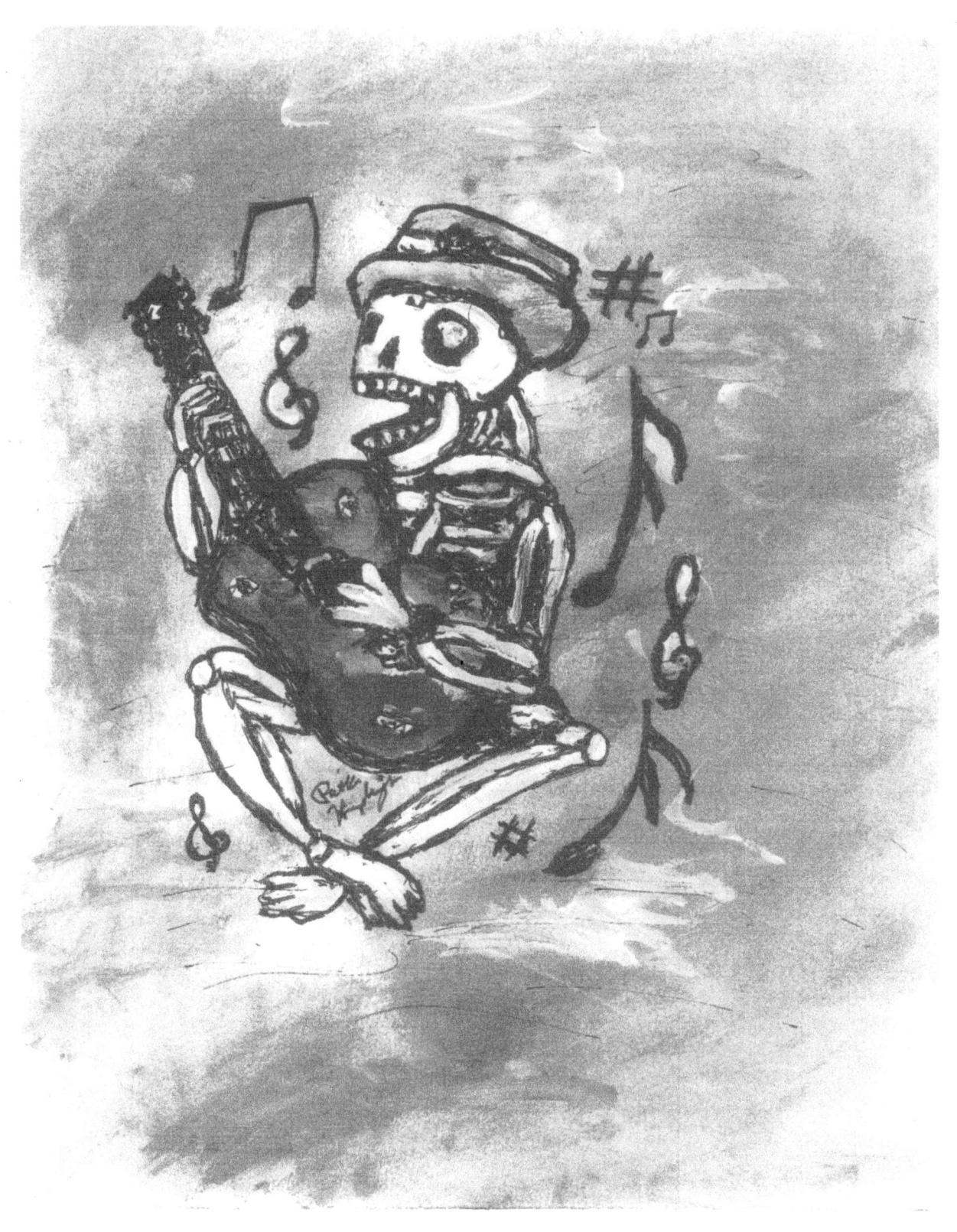

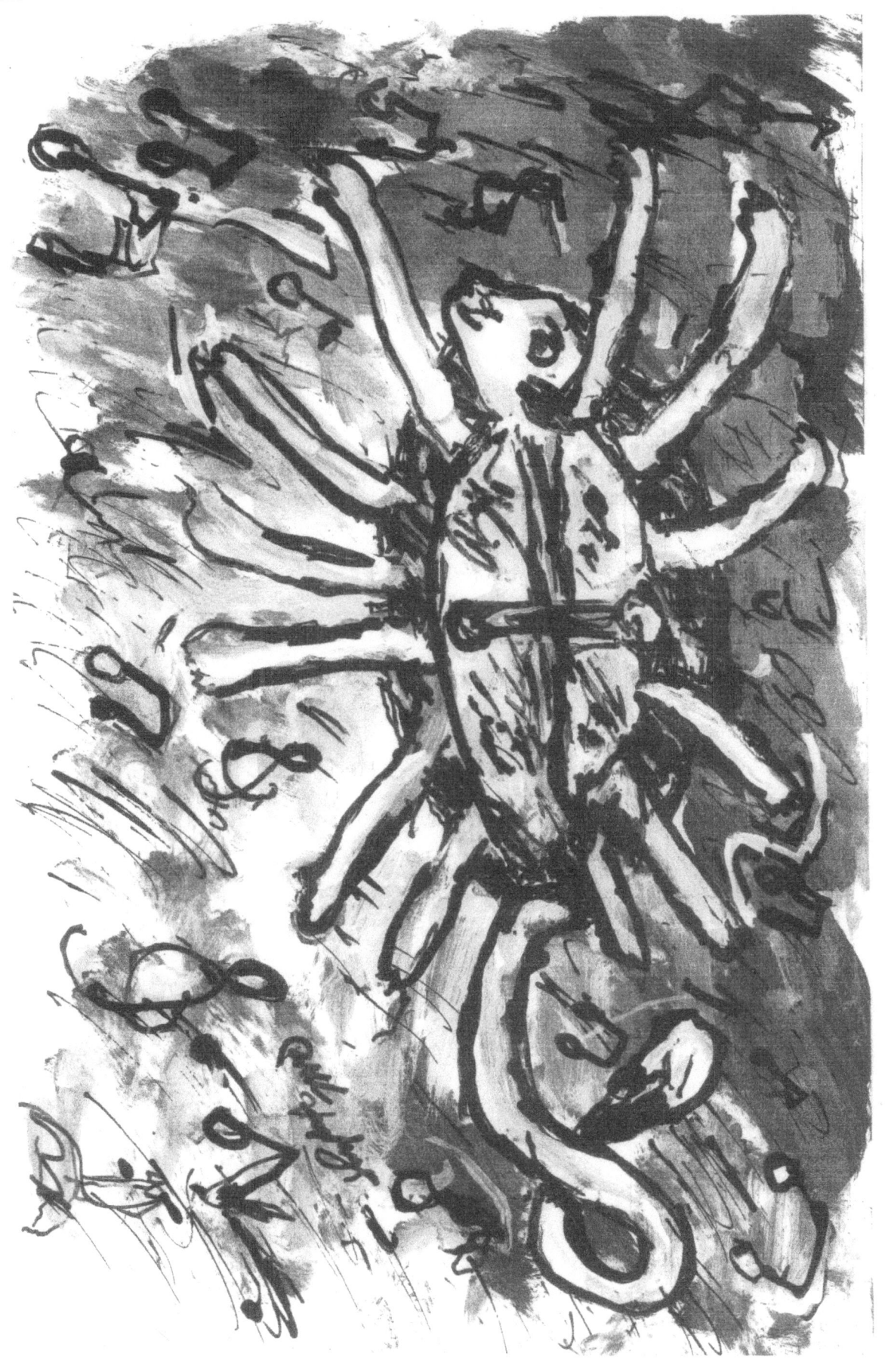

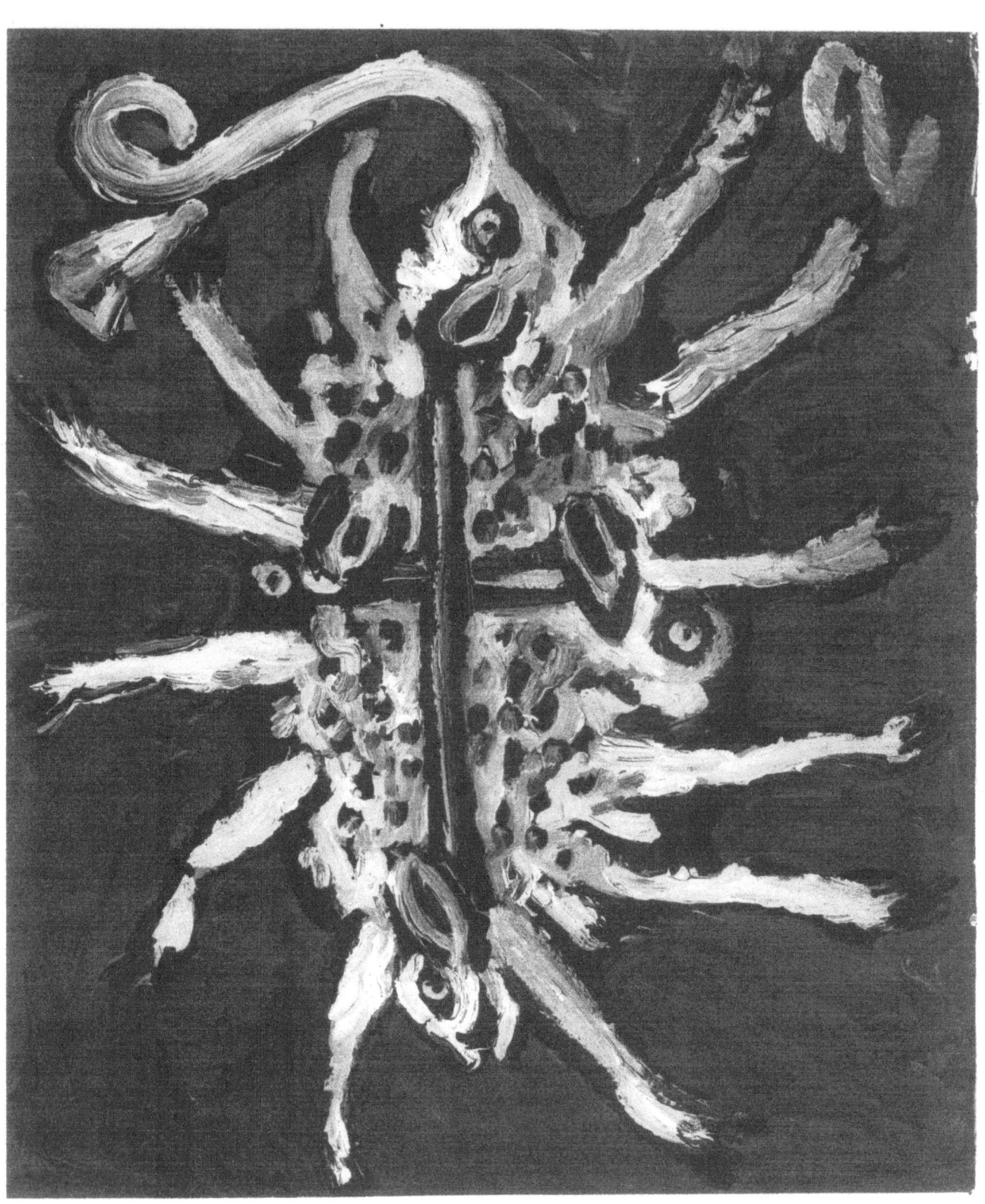

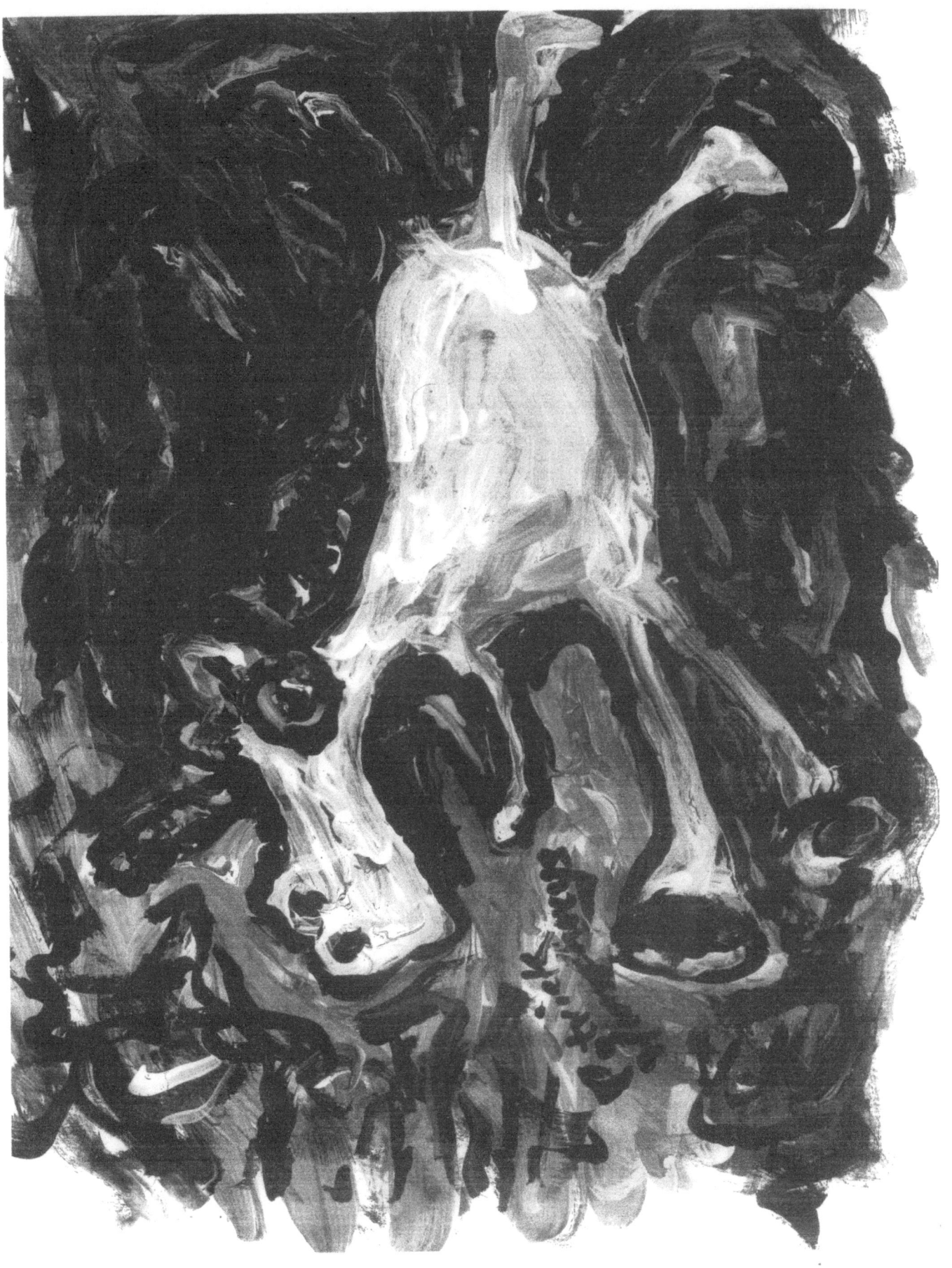

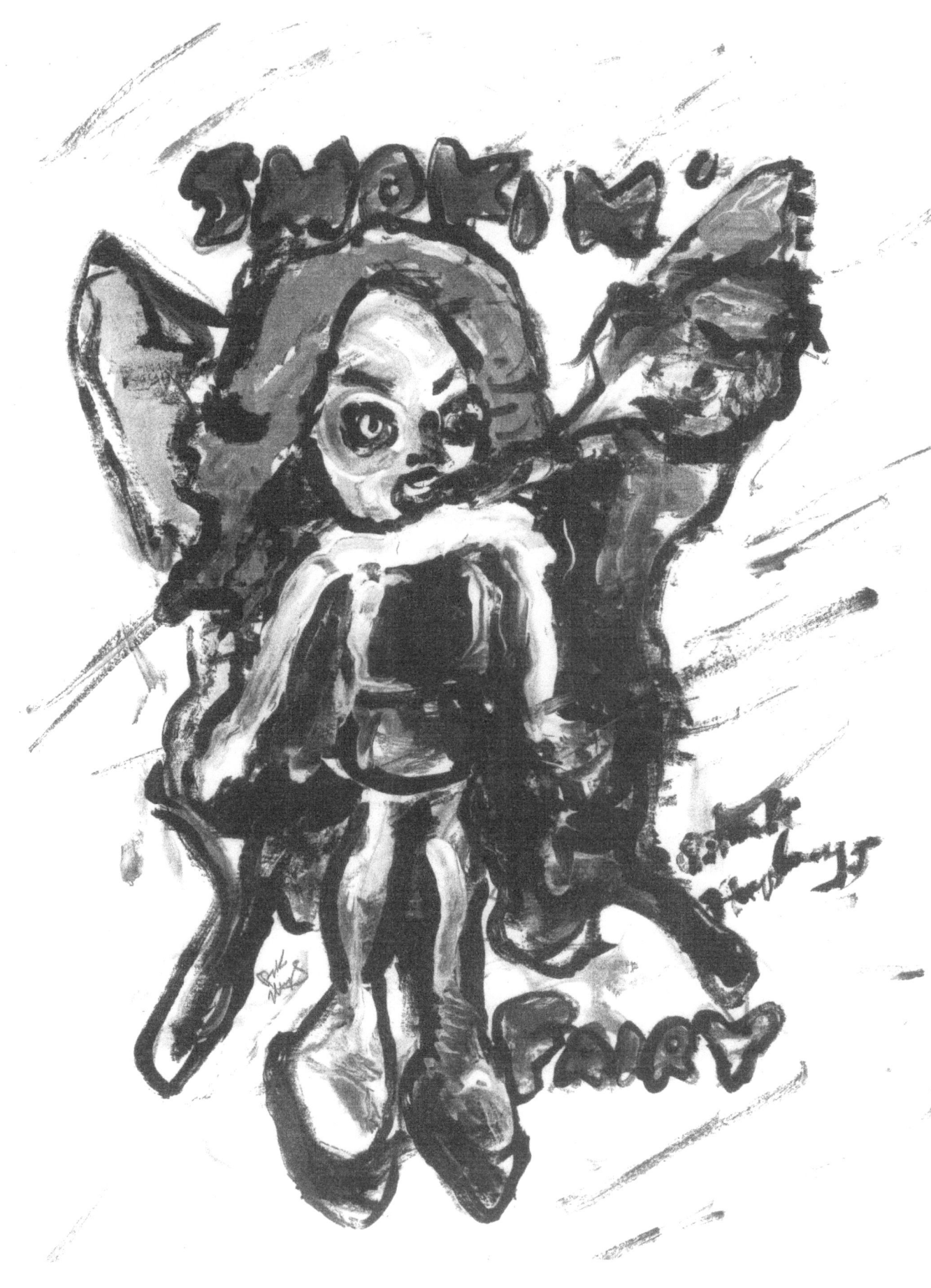

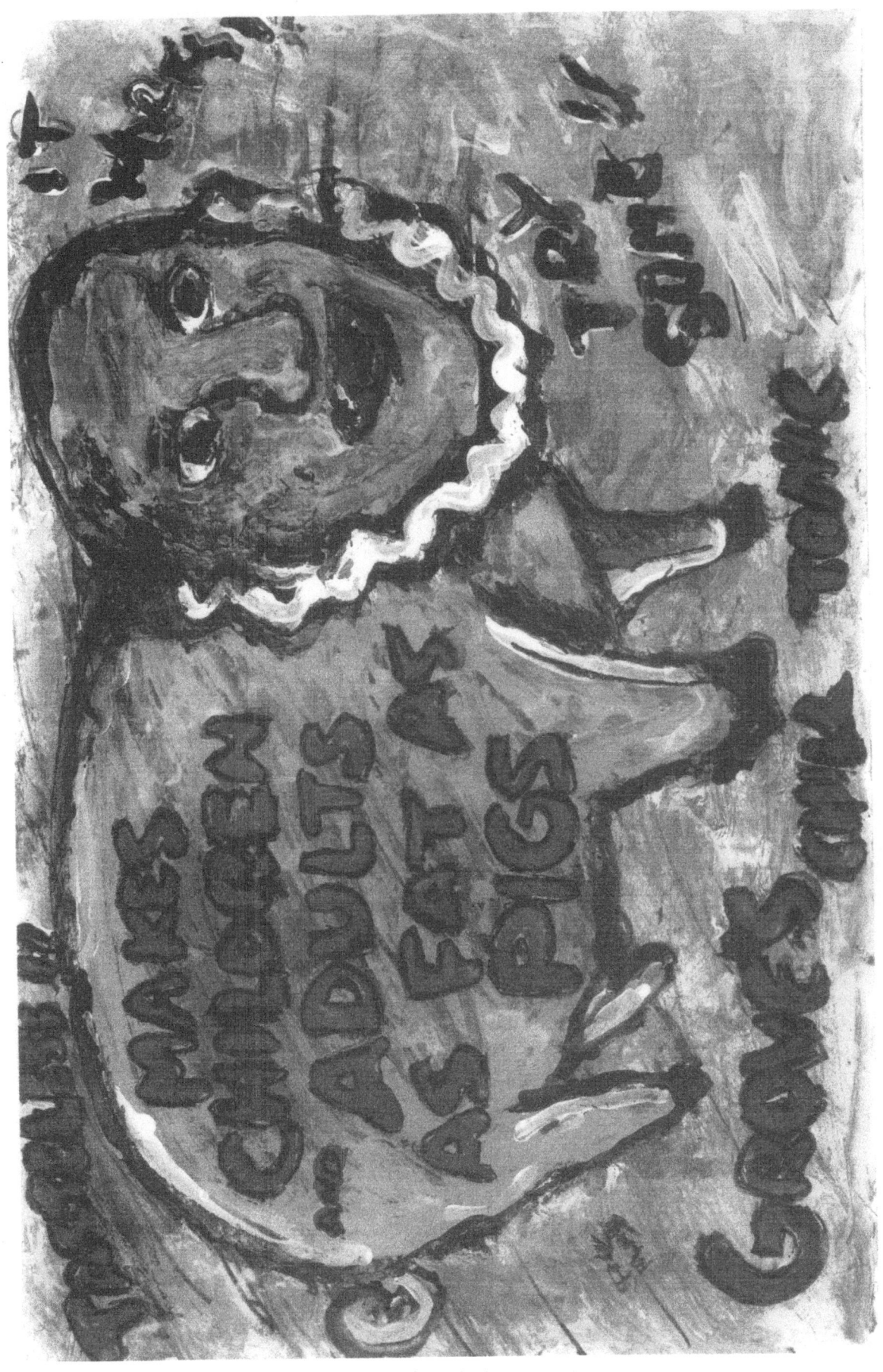

TASTE LESS!!
IT WORKS!!

MAKES CHILDREN AND ADULTS AS FAT AS PIGS

GROVE'S CHILL TONIC

www.ingramcontent.com/pod-product-compliance
Lightning Source LLC
Chambersburg PA
CBHW050909180526
45159CB00007B/2850